Postcards from the Border

Poems and Watercolor Meditations

Nancy Arbuthnot

To order additional copies of this book, contact:
Xlibris
844-714-8691
www.Xlibris.com
Orders@Xlibris.com

ISBN:	Softcover	978-1-6641-4106-3
	EBook	978-1-6641-4105-6

Library of Congress Control Number: 2020922361

Print information available on the last page.

Rev. date: 11/09/2020

CONTENTS

ACKNOWLEDGMENTS

Thanks to the organizations that hosted exhibits of the original watercolors: the Byrd Gallery at Church of the Pilgrims, Capitol Hill Arts Workshop Art Gallery, and Western Presbyterian Church, all in Washington, D.C., and the Verizon Gallery, Northern Virginia Community College, in Annandale, Virginia

DEDICATION

For all my companions on my journey to the border

For my artist and writer friends who who helped polish my poems and exhibit my paintings

And for all dreamers

INTRODUCTION

I hope to convey with this collection of watercolor and poetry sketches some of the deeply moving experiences of my ten-day mission trip to the southern U.S.-Mexico border during the winter of 2018. Then, as now, undocumented immigrants from Mexico and Central America were defying hardship, injury, arrest and death to traverse the treacherous desert of northern Mexico and the southern United States in pursuit of their dreams of life in America. The mission trip, sponsored by Western Presbyterian Church in Washington, DC and Frontera de Cristo, a border ministry of the Presbyterian Church (USA), was designed to educate participants through study and hands-on activities concerning migrants and U.S. immigration policy.

A group of us from Western—eventually, six women—had begun preparing for the trip in January 2017 with a weekly series of readings, films and discussions. At the end of December, we left DC to convene in Tucson for introductory meetings with various immigrant and migrant-support organizations. Then we headed south to the adjoining border towns of Douglas, Arizona, and Agua Prieta in Sonora, Mexico. We were housed in a church-sponsored dormitory in Agua Prieta and moved constantly back and forth across the border, often several times each day. In Agua Prieta we shared meals and conversation with maquiladores (factory workers) and their families, and with staff and residents at a migrant resources ministry, a drug rehab center, and a women's cooperative. We toured streets displaying the gaudy "narco-architecture" homes of narcotics dealers, and visited a coffee roasting cooperative where, after head-spinning and often heart-wrenching days, we found warm respite in the cafe. In Douglas, we roamed the ornate Mercantile building with its Tiffany glass windows, a reminder of the town's copper-mining heydays, and lunched with the dynamic young mayor who was creating arts initiatives to revitalize the downtown business district. We spent an afternoon at the U.S. Border Patrol office, speaking with earnest and thoughtful agents, and an evening at the weekly sunset vigil for migrants who had died that year in the desert. On Sundays, we traveled back and forth across "la frontera" for church services, first in Douglas and then in Agua Prieta.

At the end of the trip, we returned to Tucson to attend hearings at the U.S. District Court for migrants who had been arrested for crossing the border without proper documentation.

Able to extend my trip a few more days with a Frontera "homestay" in Agua Prieta, I returned to the border, where I organized the kitchen at the Frontera headquarters used by hundreds of volunteers, and assisted with classes at a local elementary school. On my last day, I managed to finagle a place aboard the Frontera van with another mission group which was bringing water to a waystation on the migrant trail across the vast, hard-scrabble land of a sympathetic ranchero. Although the water tank we planned to refill had mysteriously vanished, the young Frontera intern and the seminarian instructor led us in a powerful discussion of biblical passages about the desert.

Over the course of my few days on my mission trip, I learned (or, really, re-learned) many, many valuable lessons. Often, I was reminded how the best qualities of the human spirit—warmth and generosity and courage and joy of life—surface in trying times, and that these qualities can be found across all borders, in all walks of life. I re-discovered my fascination with Mexico—its people, food, culture, the Spanish language—that I had experienced during my childhood in southern California. I was also called to acknowledge (again) that justice does not always mean mercy, and that the rigidity of institutions can lead to callous disregard of individual suffering. The most wrenching lessons, though, were personal. Most significantly, I finally realized that what I had long considered one of my best qualities—a creative, "can do!" spirit—masked a great, unacknowledged weaknesses—my lack of "radical acceptance," my unwillingness to give up control. Yet the harshness of this lesson, and of all the hard lessons, is profoundly mitigated by what I experienced over and over again in the unforgiving bare beauty of the Sonoran desert and the dry, dusty, ugly towns of Agua Prieta and Douglas: the power of love.

The arrangement of the postcards presents a loose narrative arc from my naïve first impression of shoes at the wall, through my interactions with the borderlands and their inhabitants, to the final image of the Lincoln Memorial as a symbol of liberty and justice. This narrative arc, depicting scenes from one side of the border then the other, back and forth, is also designed to mimic my relatively fluid back-and-forth movement across the border as well as to suggest a contrast to walls, real, virtual and symbolic, that we erect against each other. Some of the poems have been revised from the original postcard versions, reflecting slightly different expressions of my experiences as I consider and reconsider my time on the border.

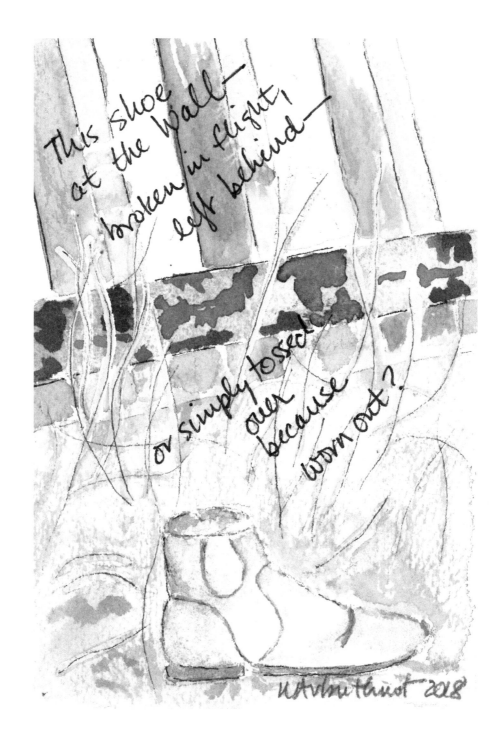

This shoe
at the Wall—
broken in flight,
left behind—

or simply tossed
over
because
worn out?

HAvhuthuot 2018

this shoe at the Wall—

broken in flight
left behind—

or simply tossed over
because outworn?

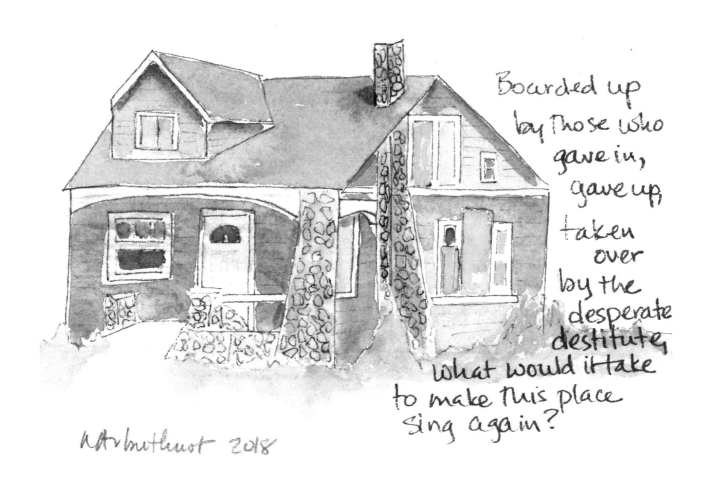

Boarded up
by those who
gave in,
gave up
taken
over
by the
desperate
destitute,
what would it take
to make this place
sing again?

NArbuthnot 2018

Douglas bungalow
boarded up
by those who gave in
gave up
taken over by the desperate destitute

what would it take
to make this place
sing again?

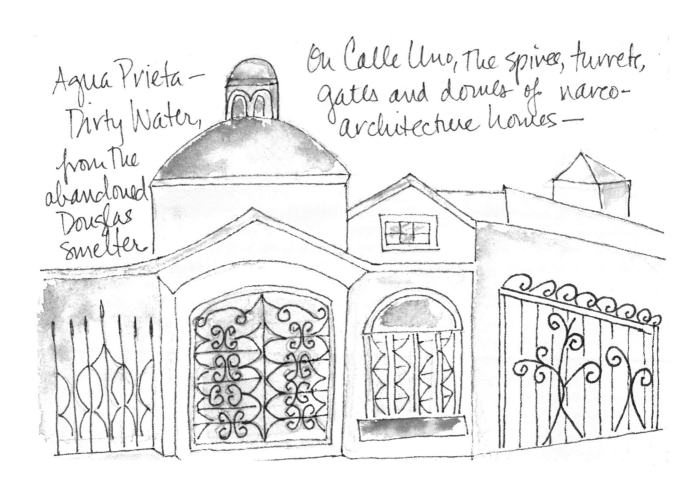

Agua Prieta—
Dirty Water,
from the
abandoned
Douglas
Smelter

On Calle Uno, the spires, turrets,
gates and domes of narco-
architecture homes—

12

Agua Prieta—Dirty Water
from the abandoned Douglas smelter

on Calle Uno
the spires, turrets, gates and domes
of narco-architecture homes

At the Mercantile,
the Phelps Dodge
Company Store,

Tiffany glass—
reminder
of days of yore

and a once
prosperous,
coppery past

adrhutchcot 2018

at the Mercantile
the Phelps Dodge company store

Tiffany glass windows—

reminders of days of yore
and a once prosperous
coppery past

They met at the seat belt factory,
bought cheap land beyond the zona electrificada
made bricks, built their casa
and working separate shifts raised a family.
Who would have thought she could find love
in this place, who would have thought
she could love a town
as ugly
as Agua
Prieta?

they met on the assembly line
of the seat belt factory
married, bought cheap land
beyond the *zona electrificada*
made bricks, built their casa
and working separate shifts
raised a family—

who would have thought
she could ever find love
in a place such as this
who would have thought
she could love a town
as ugly as Agua Prieta?

Alex, dishwasher in Holyoke
construction worker in El Paso
salmon-fisher in Alaska
caught, deported, in rehab
shimmies high, ~~says~~—

with the warning
"a backpack or a bullet"
each witching hour
you think a wall can stop
the cartels power?

18

Alex, former construction worker
from El Paso, salmon-fisher in Alaska
now drug rehab worker in Sonora
shimmies high—

you think a wall can stop
the cartel's power?
"a bullet or a backpack!"
attends each witching hour—

at the border patrol office
on display—

shoe wrapped
in carpetting
to disguise footprints

plastic jug painted black
to absorb light

mask and snorkel
for swimming the sewers

on glass display
at Border Patrol:

shoe wrapped in carpeting
to disguise footprints

plastic jug painted black
to absorb light

a mask and snorkel
for swimming the sewers

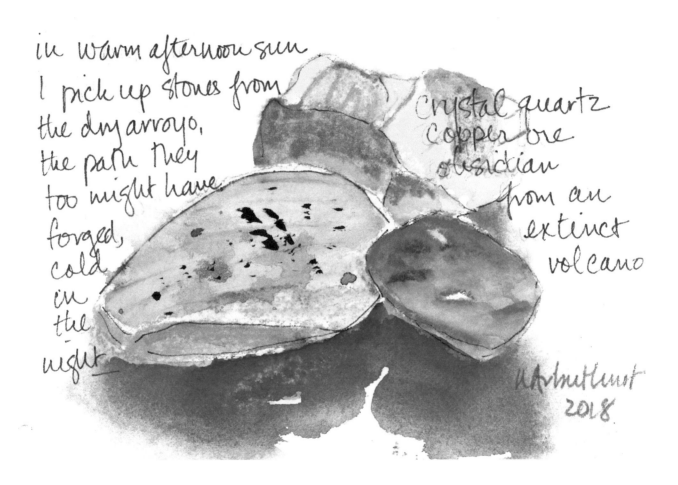

in warm afternoon sun
I pick up stones from
the dry arroyo,
the path they
too might have
forged,
cold
in
the
night

crystal quartz
copper ore
obsidian
from an
extinct
volcano

MArbuthnot
2018

22

in warm afternoon sun
I pick up stones
from the dry arroyo
the path they too might have forged
cold in the night—

crystal quartz
copper ore
obsidian from an extinct volcano

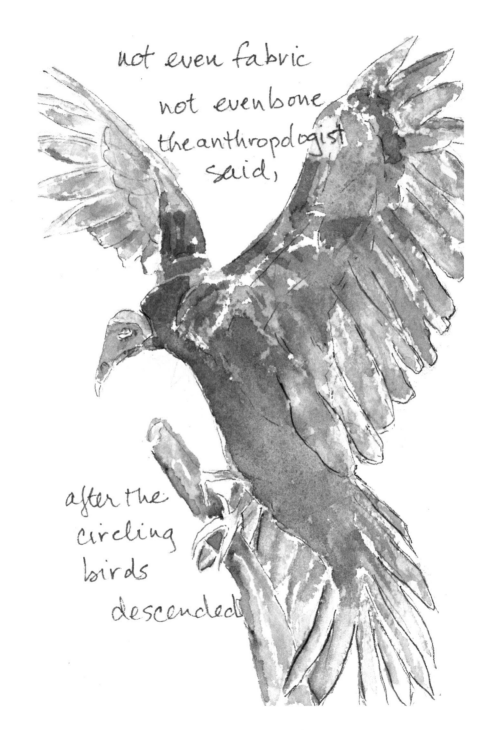

not even fabric
not even bone
the anthropologist
said,

after the
circling
birds
descended

not even fabric
not even bone
the anthropologist said

after the circling birds
descended

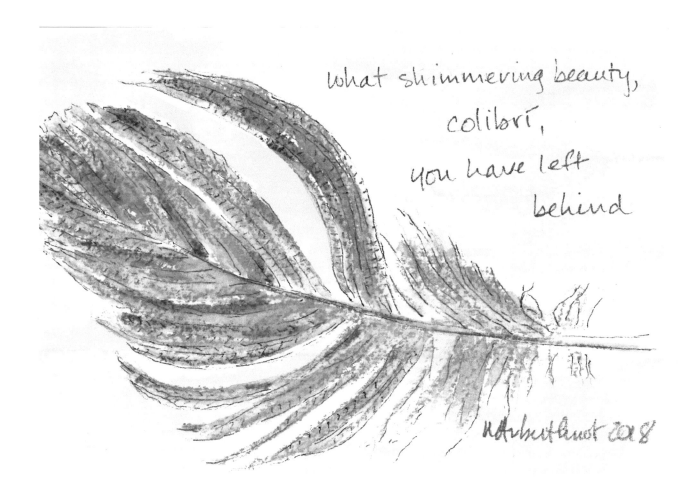

what shimmering beauty,
colibrí,
you have left
behind

n.douglas stewart 2018

what shimmering beauty
colibrí
you have left behind

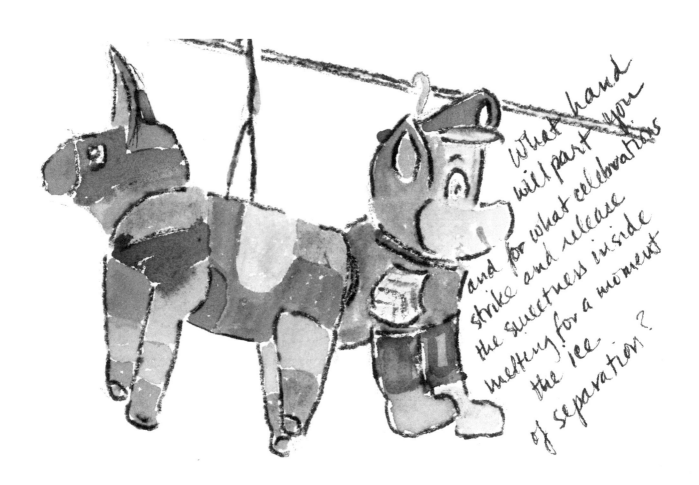

What hand
will part you
and for what celebrations
strike and release
the sweetness inside
melting for a moment
the ice
of separation?

piñatas, side by side
in the Douglas Walmart—
Mexican donkey
doggy U.S. Border Guard—

what hands will part you
and for what celebrations
strike and release
the sweetness inside?

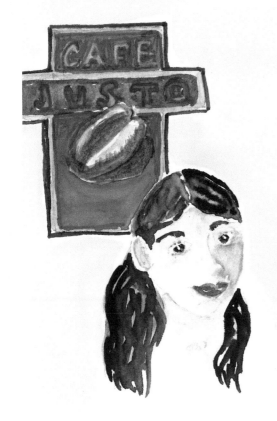

dark-eyed daughter
of Mexican mother & Anglo father
with red-lipped laughter
drawing us — Three women
on a mission trip —
into The cafe of migrants,
students, pastors, police —
"Oh, don't you just love
 the border?"

dark-eyed daughter
of Mexican mother and Anglo father

with red-lipped laughter drawing us—
three women on a mission trip—
into the café stirred hot with migrants
students, police, pastors—

"Oh, don't you just love the border?"

his father's beatings
no school or work
 in Veracruz
at 16 he ran off —

now waiting to cross
he wins bets fighting
 (no one expects him
 so small
 to be so tough)

 y su madre?
 we ask
 y el peligro?

 todo para ella
 no tengo miedo
 he scoffs

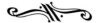

his father's daily beatings
no school or work in Vera Cruz
at 16 he ran off

the bets he wins streetfighting —
no one expects him, so small
to be so tough—
will help him cross

y su madre?
we ask in broken Spanish
y el peligro?

todo para ella, he says
no tengo miedo, he scoffs

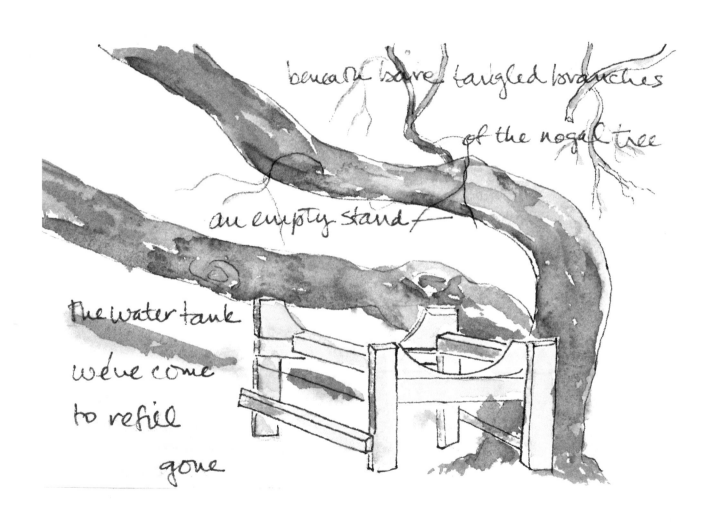

beneath bare tangled branches

of the nogal tree

an empty stand

the water tank
we've come
to refill
gone

beneath the nogals' tangled branches

dark nut husks
and an empty wooden stand—

the water tank we've come to refill
gone

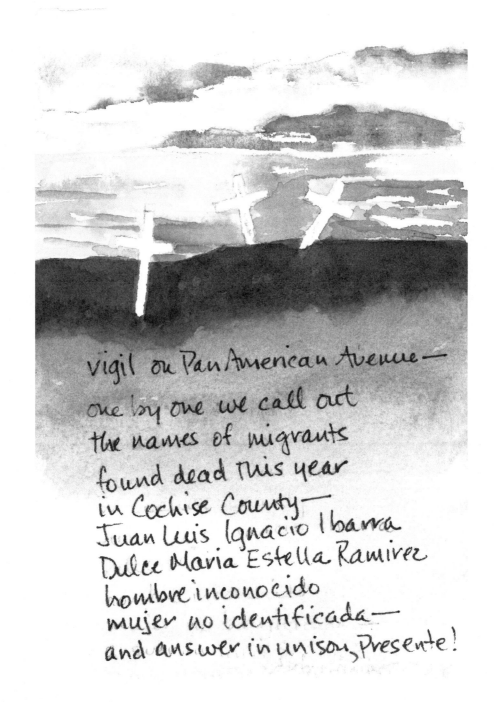

vigil on Pan American Avenue—

one by one we call out
the names of migrants
found dead this year
in Cochise County—
Juan Luis Ignacio Ibarra
Dulce Maria Estella Ramirez
hombre inconocido
mujer no identificada—
and answer in unison, Presente!

vigil on Pan American Avenue—

one by one we call out
the names of migrants
found dead this year
in Cochise County—

Juan Luis Ignacio Ibarra
Dulce Maria Estela Ramirez
homebre inconocido
mujer no identificada—

and answer in unison
!Presente!

O lost one, did you, before bequeathing
your soul, to the infinite
breathe with your eyes
the white cloud of the Orion Nebula
That copal smudge,
The healing aroma
waned over you
a child
in abuela's arms?

o lost one

before bequeathing
your soul to the infinite

did you breathe with your eyes
the white cloud of the Orion Nebula

that copal smudge
healing aroma waved over you

a child
in abuela's arms?

from the oyamel, sacred fir
in the cloud forests of central Mexico
you take flight, majestic one
riding a strong south wind
　　flap flap glide
　　　flap flap glide
over the Rio
　　Grande

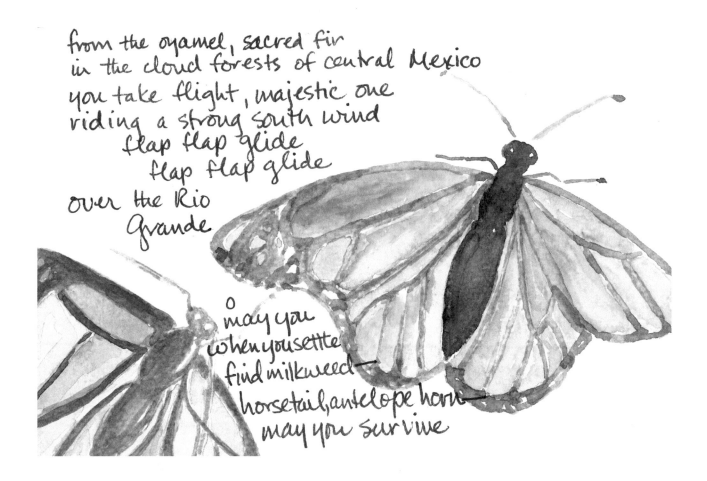

o
may you
when you settle
find milkweed —
horsetail, antelope horn —
may you survive

from the oyamel
sacred fir in the cloud forests
of central Mexico

you take flight
majestic one
riding a strong south wind
flap flap glide
flap flap glide
over the Rio Grande

when you settle
may you find milkweed—
horsetail, antelope horn—

may you survive

golden treasure of the Sierra Madre
powerful, elusive, at home between earth & sky—
will she be the one
to leave these craggy heights
follow the scent north
to El Jefe, solitary
stalking the scrubland
or will
the fence of extinction
stop her
dead in her tracks?

golden treasure of the Sierra Madre
powerful, elusive
at home on the craggy heights
between earth and air—

will she be the one to leave
the remote jungle
follow the scent of El Jefe
north beyond the border
the scrub desert he skulks
solitary

or will the fence of extinction
stop her
dead in her tracks?

Beyond the Wall
dipping, rising
as the land falters and heaves
Beyond the mesquite desert sea
the jagged mountain range,
sky islands of the Chiricahuas

beyond the Wall
dipping, rising
as the land falters and heaves

beyond the mesquite desert sea
the jagged mountains
sky islands of the Chiricahuas

in the courtroom, silence
between question
& translation

Do you plead guilty?
Do you understand?
at the microphone the young Mayan
adjusts headphones brushes back long hair
& understanding no other word is possible
replies, the single untranslated syllable
splicing the sleek immaculate air

the young woman
before the microphone
in the U.S. District Court
brushes back long hair
adjusts headphones—

Do you plead guilty
Do you understand?

silence
in the distance between
question, translation

then understanding
no other word is possible
she answers

the single untranslated syllable
slicing the sleek immaculate air

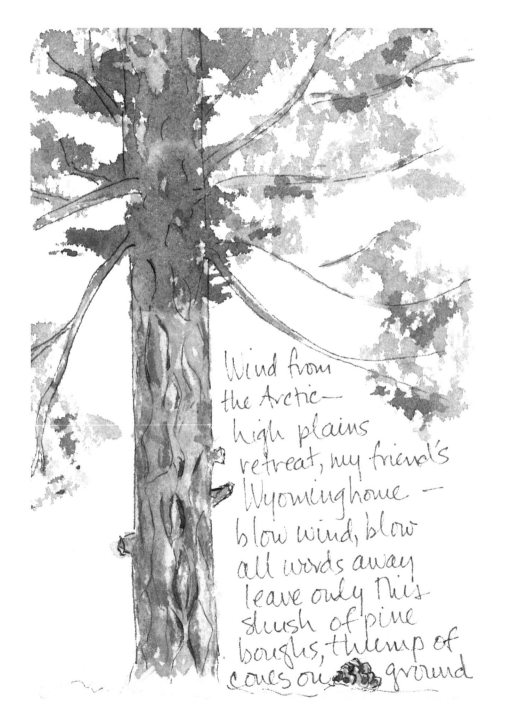

Wind from
the Arctic—
high plains
retreat, my friend's
Wyoming home —
blow wind, blow
all words away
leave only This
slush of pine
boughs, thump of
cones on ground

wind from the Arctic—
high plains retreat
my childhood friend's Wyoming home—

blow, wind
blow all words away
leave only this shush of pine boughs
thump of cones on ground

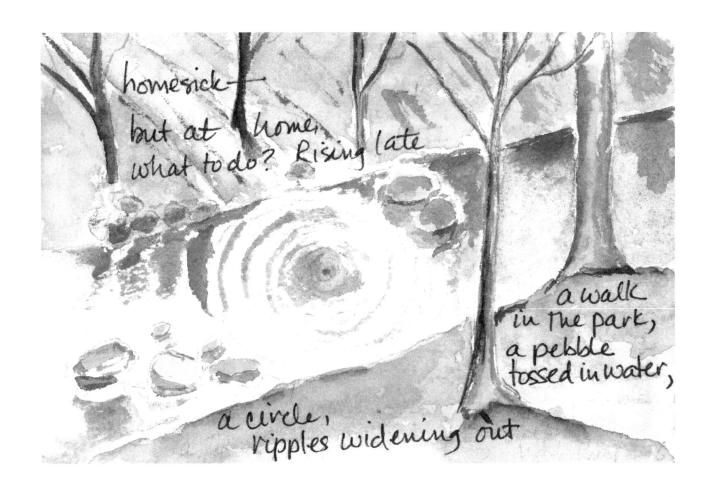

homesick—

but at home
what to do? Rising late

a walk
in the park,
a pebble
tossed in water,

a circle,
ripples widening out

homesick—
but at home
what to do?

rising late
a walk in the park
a pebble
tossed in water

a circle rippling out
circles ever-widening

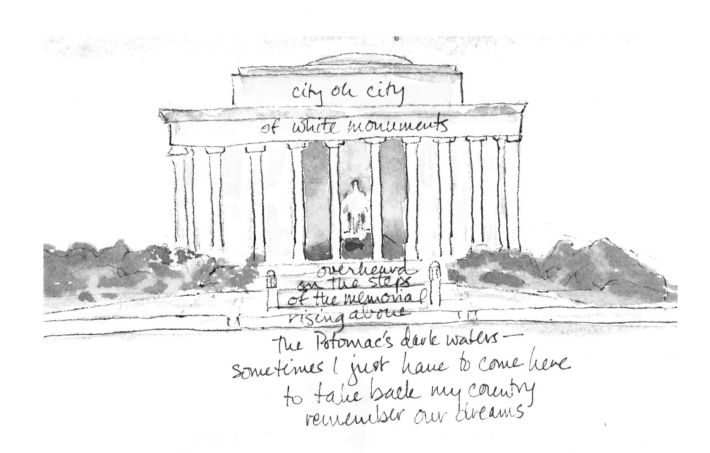

city oh city

of white monuments

overheard
on the steps
of the memorial
rising above

the Potomac's dark waters—
sometimes I just have to come here
to take back my country
remember our dreams

city oh my city
of white monuments
rising above dark Potomac waters—

overheard on the steps
of the Lincoln memorial

sometimes I just have to come here
to take back my country
remember our dreams

Printed in the United States
By Bookmasters